D1265574

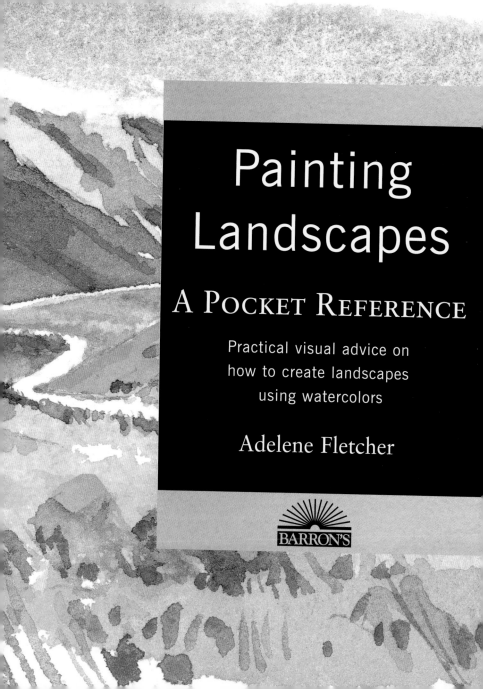

Painting
Landscapes

A POCKET REFERENCE

Practical visual advice on
how to create landscapes
using watercolors

Adelene Fletcher

BARRON'S

A QUARTO BOOK

Copyright © 2003 Quarto Inc.

All inquiries to be addressed to:
Barron's Educational Series, Inc.
250 Wireless Boulevard
Hauppauge, NY 11788
http://www.barronseduc.com

Library of Congress Catalog
Card Number 2002107383

ISBN 0-7641-5613-6

9 8 7 6 5 4 3 2 1

CODES

****	Extremely permanent
***	Permanent
**	Moderately durable
*	Fugitive color

G	Granulating color
O	Semi-opaque/opaque
Tr	Semi-transparent/ transparent
St	Staining color

COLORS USED IN THIS BOOK

new gamboge
***Tr

lemon yellow
***O Tr

transparent
yellow***St Tr

light red
****O

cadmium
red***O G St

permanent
rose***Tr St

raw sienna
****Tr

raw umber
****Tr

burnt sienna
****Tr

cobalt blue
****Tr

cerulean blue
****O

French ultramarine
***Tr

green gold
***Tr

sap green
**Tr St

oxide of
chromium****G S

dioxazine violet
***Tr

cadmium
orange***O

indigo***O St

CONTENTS

quinacridone
gold***St T

translucent
orange****Tr

alizarin
crimson**T

brown
madder**T

burnt umber
****O

sepia
***O

Prussian
blue**Tr St

phthalo blue
***Tr St

phthalo green
***Tr St

olive green
***T St

white gouache
***O

HOW TO USE THIS BOOK 4

BEFORE YOU START 5

LOOKING AT LANDSCAPE 6

USING COLOR 8

TECHNIQUES 10

THE LAND 14

UNDERGROWTH 20

TREES 24

SKIES 33

MOUNTAINS 38

INLAND WATER 44

WALLS AND FENCES 52

BRIDGES 56

ROADS 58

FARMING 60

CREDITS 64

HOW TO USE THIS BOOK

THE AIM OF this book is to demonstrate a series of landscape paintings, exposing the watercolor artist to a broad range of techniques and effects. The comprehensive introduction sets out many of the issues that will be encountered both by the beginnner and the more experienced artist. The projects are ordered thematically so that the scope and potential for the breadth of subject matter can be seen at a glance. Step-by-step demonstrations illustrate the particular techniques used, clearly setting out the colors needed at the top of each page.

The colors required for each painting are set out along the top of the page, so that exactly what is required is immediately clear.

Projects are divided into broad subsections, which can be seen at a glance across the top of each page.

Written instructions are balanced with visual images throughout, making the book ideal to use both as a quick reference or as a more detailed guide.

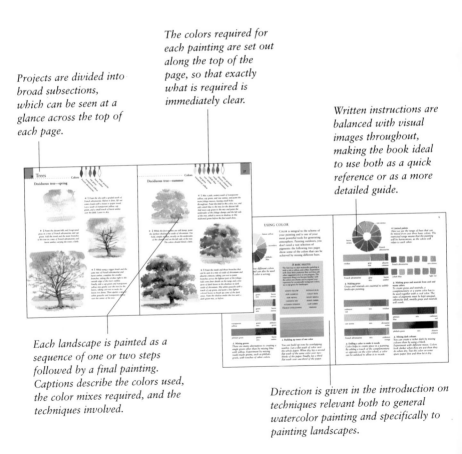

Each landscape is painted as a sequence of one or two steps followed by a final painting. Captions describe the colors used, the color mixes required, and the techniques involved.

Direction is given in the introduction on techniques relevant both to general watercolor painting and specifically to painting landscapes.

BEFORE YOU START

BEFORE YOU START to paint, it is worth taking the time to consider both your subject matter and the materials appropriate for this. One of the joys of watercolor painting is that you actually need very little specialized equipment—just paints, paper and brushes. Always buy the best quality you can afford.

MATERIALS
Pans of paint are often more convenient than tubes for painting outdoors as they are easier to carry. You do not need lots of brushes: a number 6 and a number 12 together with a large, square-ended brush for washes are enough to begin with. In terms of paper, there are three types of surfaces—hotpressed (HP), coldpressed (CP), and rough. HP paper is good for linear work where you might want to record fine detail but not so good for painting built up in layers. CP is good for both washes and fine detail. Rough watercolor paper is heavily textured; the paint sits on the raised surfaces, giving a speckled effect.

CHOOSING YOUR SUBJECT MATTER AND COMPOSITION
Whenever possible, walk around your subject to see what elements of the scene interest you most. A viewfinder can be a helpful way of deciding how much to include—just cut a rectangle from a piece of cardboard to frame the view. Explore the compositional possibilities of your subject, trying out different ideas and formats, as shown in the sketches.

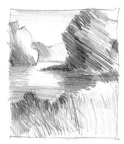

▲ **Square format**
A square format shows more of the foreground grasses and flowers. The tree trunks have been excluded.

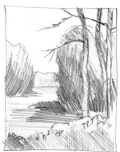

▲ **Vertical format**
A vertical format shows more sky and gives more prominence to the tall tree trunks on the right.

▶ **Horizontal format**
Think of your subject in terms of simple shapes when making a compositional sketch, and roughly block in the main areas of light and shade to see how they balance. Here, a high horizon line means that little sky is visible and the foreground and water dominate the image.

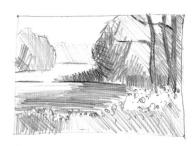

LOOKING AT LANDSCAPE

OBSERVING SHAPE AND FORM

The key to realistic landscape painting is to make your subjects look three-dimensional—and very often the best approach is to simplify things. Start by trying to reduce elements of the landscape to basic shapes. When you are painting a conifer, for example, think of it as a simple cylinder shape—the trunk—with a cone over the top—the foliage.

See these solid shapes of the landscape as an abstract design of interlocking shapes. Once you have established the basic shapes, you can start to add the tones and details that will make your painting look lifelike.

UNDERSTANDING LIGHT AND SHADE

Usually, light falls onto objects from one direction, putting some parts into shadow. This is what makes things look three-dimensional. Understanding light and shade is the essence of painting. The best watercolor paintings use contrasts of tone to create a realistic, three-dimensional effect. Design the grouping of the light and dark areas in the scene to form interesting patterns.

SCALE AND DISTANCE

There are three main things to remember when you are trying to create a sense of space and distance in your paintings:

SIZE

The farther away an object is, the smaller it appears. This affects linear perspective, as shown in the diagram below.

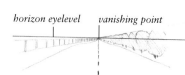

horizon eyelevel vanishing point

◀ **Linear perspective**
Parallel lines appear, if extended, to meet at a vanishing point.

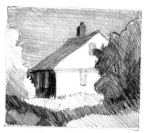

▲ **Lights and darks**
Organize the design of the lights and darks. Juxtaposing the lightest and darkest tones in a painting makes for an exciting composition.

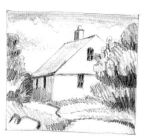

▲ **Tonal contrast**
If there is not enough contrast between the tones in a sketch or painting, as here, it will look flat and monotonous.

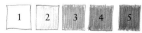

▲ **Tonal strip**
To train your eye to judge tones correctly, make a tonal strip. Gradually, you will find it easier to judge tones and mix your colors accordingly.

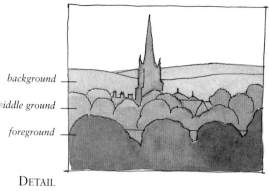

background

middle ground

foreground

◄ **Creating distance**
*Detail is implied if you create a
foreground, middle ground, and
background in your paintings,
and then reduce the tonal range
of each area as it recedes into
the distance.*

DETAIL

The nearer an object is to you, the more clearly you can see the detail on it.
Paint more detail on objects in the foreground.

TONE

Tones in the distance are more muted than those in the foreground. Creating
three distinct areas is a good way of implying distance. The effect of this is
shown in the sketch above. You may also find it helpful to use a tonal strip as
shown opposite. Imagine what your subject would look like if it was a black-
and-white photograph; you may find it helpful to hold the tonal strip up and
compare the values.

ACHIEVING THE RIGHT LEVEL OF DETAIL

Very often, a suggestion of detail is enough, as seen in the example of massing
below. The challenge is to include enough detail to look convincing without
overdoing it. Simplify your painting to accentuate a detailed area.

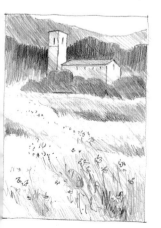

► **Massing**
*Descriptive brush marks
are enough to suggest
the leaf texture in this
complex mass of foliage.*

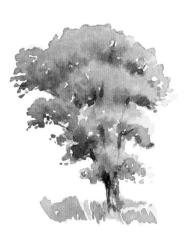

◄ **Tuscan scene**
*Use crisp details and
contrasting tones at the
focal point and softer
tones and shapes as you
move away from the
center of interest.*

USING COLOR

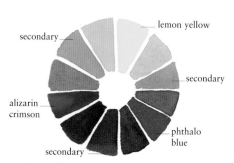

secondary

lemon yellow

secondary

alizarin crimson

phthalo blue

secondary

▲ **Color theory**
Color wheels show how different colors relate to each other and can also be used to identify if a mixed color is wrong.

COLOR is integral to the scheme of your painting and is one of your most powerful tools for generating atmosphere. Painting outdoors, you don't need a vast selection of pigments: the following two pages show some of the colors that can be achieved by mixing different hues.

A BASIC PALETTE

The best way to start watercolor painting is with a red, a yellow, and a blue. Experiment with these three primaries first and then add other suggested colors as you progress. The important thing is to become familiar with the colors you choose and to expand your repertoire by occasionally trying new colors, say a sap green for landscapes.

LEMON YELLOW	PHTHALO BLUE
NEW GAMBOGE	COBALT BLUE
RAW SIENNA	BURNT SIENNA
CADMIUM RED	BURNT UMBER
ALIZARIN CRIMSON	RAW UMBER
FRENCH ULTRAMARINE	VIRIDIAN

phthalo green	green mix	burnt sienna

phthalo green & transparent yellow	green mix	burnt sienna

transparent yellow	green mix	phthalo green

phthalo green	green mix	burnt umber

▲ **Mixing greens**
There are many alternatives to creating a single green other than by mixing blue with yellow. Experiment by mixing ready-made greens, such as phthalo green, with touches of other colors.

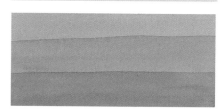

▲ **Building up tones of one color**
You can build up tone by overlapping washes. Lay a flat wash of color over the whole paper. When dry, lay a second flat wash of the same color over two-thirds of the paper. Finally, lay a third flat wash over one-third of the paper.

raw sienna

burnt sienna

French ultramarine

◄ Limited palette
Here we see the range of hues that can be mixed from just three basic colors. The restricted range means that the painting will be harmonious, as the colors will relate to each other.

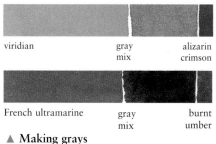

viridian — gray mix — alizarin crimson

French ultramarine — gray mix — burnt umber

▲ Making grays
Grays and neutrals are essential to subtle landscape painting.

French ultramarine — raw sienna

cobalt blue — light red

▲ Making grays and neutrals from cool and warm colors
To create grays and neutrals, a complementary or a warm color has to be used together with a cool color. The ratio of pigments must be kept unequal, otherwise dull, muddy grays and neutrals will result.

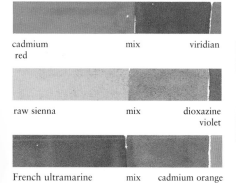

cadmium red — mix — viridian

raw sienna — mix — dioxazine violet

French ultramarine — mix — cadmium orange

▲ Dulling a color to make it recede
Color helps to create space in a painting. By adding a touch of the complementary or opposite on the color wheel, a color can be subdued to allow it to recede.

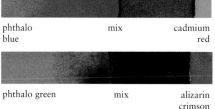

phthalo blue — mix — cadmium red

phthalo green — mix — alizarin crimson

▲ Mixing dark colors
You can create a richer dark by mixing colors than by using a black. Experiment with different mixes. Colors look darker when they are wet than they do when dry. Test the color on some spare paper first and then let it dry.

TECHNIQUES

Washes are the most fundamental of all watercolor techniques. There are several kinds.

FLAT WASH

Always mix more paint than you think you will need: if you have to stop halfway through to mix more, the wash will dry with a distinct line at the point where you stopped. Dampen the paper with a large brush (or with a sponge if you are covering a large area). Start at the top, with the board tilted at a slight angle to allow the paint to flow down, and brush a well-loaded brush from side to side, slightly overlapping the previous stroke. Do not go back into the wash to correct it, otherwise the paint will not dry to a consistently flat finish.

GRADED WASH

A graded wash is useful for painting a blue sky to show recession. Start at the top of the paper with a strong color and gradually lighten it with more water as you proceed to the horizon. Here the wash was painted wet on dry, but dampen the paper first if you are covering a large area.

VARIEGATED WASH

A variegated wash is good for painting a sunset, where you have several different colors in the sky. Here, a graded blue wash was painted over the top half of the paper. Then, while working from the bottom of the paper upwards, a graded yellow wash was painted up to the point where it slightly overlapped the pale blue. Finally, a warm burnt sienna was brushed on at the lower edge to blend.

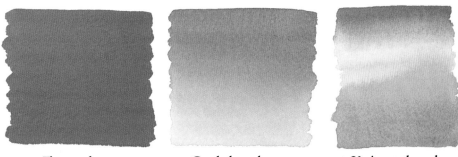

▲ Flat wash ▲ Graded wash ▲ Variegated wash

GLAZING

Glazing means applying very dilute, transparent colors one on top of another, wet on dry, to build up colors. Here, two tones of warm yellow were brushed on and allowed to dry. Then a warm blue was brushed over the top. Note how the first wash shows through the second layer. This color combination suggests a shadow on the side of a wall. Do not fiddle with the color or you could disturb the underlying wash.

▲ **Glazing**

DRYBRUSH

This technique requires a little practice and works best on CP or rough paper. It is used to create texture and broken-color effects. Use a dry brush loaded with very little paint—and use only enough water to make the paint workable. If you use too little paint, it will not cover the paper at all, while too much will give an irregular wash.

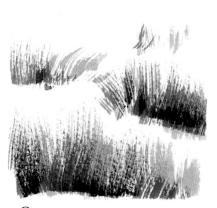

▲ **Grass**
Build up the grasses in three tones, from light to dark, letting each stage dry before adding the next. Use a small flat brush with very little paint. Concentrate on fanning out the bristles with your fingers, brushing the strokes upwards from the base of the grasses.

▲ **Water**
Here the drybrush technique is used to describe the sparkle on the water. Experiment with a flat or round brush, and stroke the color across the paper. Repeat the process at the lower edge to make the water darker and give a feeling of recession.

SCUMBLING

Scumbling means working over a dry area with a scrubbing motion so that the paint is applied in many directions. It is a very useful technique for conveying texture—such as on old buildings, to make them look weathered. It could also be used to describe the texture on mountains, dragging the paint over to suggest the form. In transparent watercolor, you can scumble only a dark color over a light one.

◄ Scumbling
1. First, apply a wash of warm yellow and leave to dry. Then, while using very dry paint, drag the side of a large round brush unevenly over the paper, leaving some of the first wash showing through. Here, two darker tones were used: the first scumble was allowed to dry before the second one was applied over it.

▲ *2. By mixing thick white gouache with a little of the previous scumble colors, you add lighter texture to the wall add more interest. Complete sketch by adding dark details the roof and doors when everything else is dry.*

DIRECTIONAL BRUSHWORK

Varying the direction of your brush strokes so that they follow the form of your subject—for example, by using curving strokes around a cylindrical form—can help to create a three-dimensional effect in your paintings. Experiment with different brushes, from a large flat brush to paint movement in the sky to a rigger brush to suggest bark texture on a tree with slender lines.

▲ Deciduous foliage
Light and feathery strokes suggest delicate clusters of small leaves. The brushwork follows the direction of the clumps of foliage. Vary the degree of pressure on the brush to make larger or smaller marks.

◄ Grasses
Here a rigger brush was used to make thin, diagonal strokes and convey the feeling of grasses blowing in the breeze.

MASKING

Masking fluid allows you to create hard-edged, precise highlights, or to protect small, light details that would be difficult to paint around. Use an old brush, preferably synthetic or a nib pen. Let the fluid dry, then wash color over the fluid, which acts as a resist. When dry, rub off the masking fluid, revealing the white paper underneath.

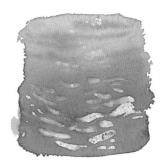

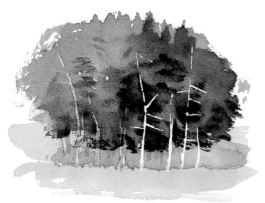

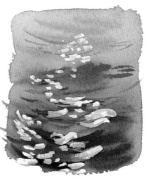

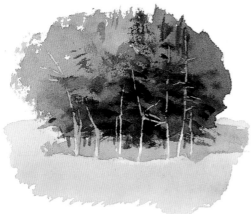

▲ Water
First, mask out ripples on the water. Then apply a graded wash, and make slightly darker strokes in the same color before it dries. Add still more very dark brush marks, making them thinner as they recede upward. Allow to dry. Rub off the masking. Tint the revealed shapes with another color as required.

▲ Group of trees
Use a small brush to paint the tree trunks and some branches in masking fluid. When dry, lay a wash over the land, and leave to dry. Then brush in the three tones of green for the foliage. Allow to dry, then add blue shadow under the trees. When all is dry, rub off the masking. Tint the revealed trunks and branches to match the foreground, adding additional foliage across the trunks if needed.

The Land

Plowed field

Colors

cobalt blue raw umber burnt sienna French ultramarine burnt umber sepia

◀ **1** *On rough watercolor paper, sketch the position of the trees and the main lines of the furrows, making them narrower as they recede into the distance. While starting at the top, lay a variegated wash of pale cobalt blue, changing to raw umber midway, and adding burnt sienna at the lower edge. Leave to dry.*

▶ **2** *Paint the distant hills with midtoned French ultramarine. Paint the farthest field with a wash of burnt umber to show up the light on the plowed field ridge. Mix burnt umber with a small amount of French ultramarine, and paint the shadows on the furrows, using dry brush strokes.*

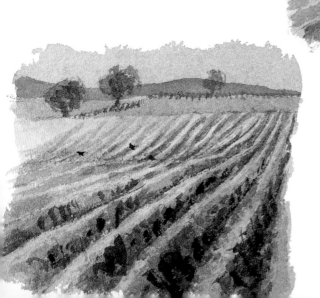

◀ **3** *Mix French ultramarine and sepia. Apply to the furrow shadows with a drybrush to suggest the soil texture. While still using a drybrush, paint the shapes of the distant trees in a paler mix of the same color.*

Colors

cerulean blue / new gamboge / sap green / olive green / permanent rose / cadmium red / dioxazine violet

Grassy meadow with poppies

◀ **1** *Use masking fluid to mask the shapes of the poppies, making them smaller and closer together as they recede into the distance. Paint a strip of cerulean blue for the sky, then wash pale new gamboge over the rest of the paper for the field. While the paint is still wet, drop in some sap green in the middle and darker olive green toward the bottom of the paper, allowing the colors to blend.*

▶ **2** *While the wash is still damp, dot in strips of permanent rose to suggest poppies in both the distance and the foreground. When this is dry, mix sap green and olive green, and paint a few vertical strokes in the center of the image and in the foreground. Spatter a little of the same color in the foreground. Mix sap green and cerulean blue, and add the shapes of the distant trees. When everything is dry, rub off the masking fluid.*

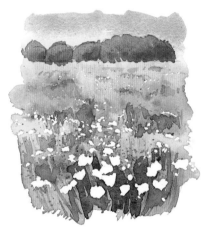

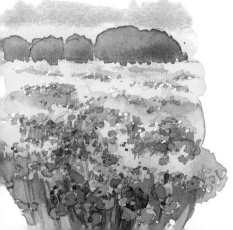

◀ **3** *Paint the poppies with mixes of cadmium red and permanent rose, making the color stronger and brighter in the foreground flowers. Finally, add touches of dioxazine violet in some of the larger flower centers.*

The Land

Wildflower meadow

raw sienna sap green permanent rose olive green phthalo green alizarin crimson new gamboge

◀ **1** *Use masking fluid to mask the daisies, some buttercups, and the grasses. All flower meadows have a pink cast in their coloring. To indicate this, start at the top and lay a variegated wash of raw sienna going into sap green, and let the two colors merge. While this is still wet, tease out some grasses on the top edge in watery permanent rose, using a fine brush. Drop darker dots of permanent rose onto the foreground sap green to suggest clover.*

▶ **2** *While the first wash is still damp, paint dark strokes in the foreground using a mix of olive green and phthalo green. Add alizarin crimson to this mix, and use it to paint some stalks and grasses. Allow the paint to dry, then rub off the masking fluid.*

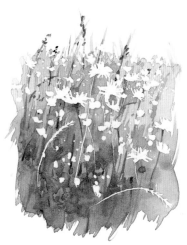

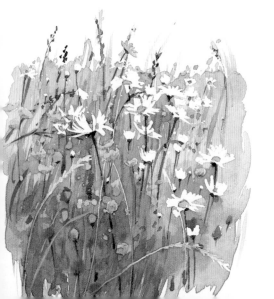

◀ **3** *Paint in the small buttercups and the daisy centers with new gamboge. Tint the grasses with raw sienna, and finally add a few more dark olive green stalks.*

Fields of corn harvested

Colors

Prussian blue new gamboge raw sienna burnt sienna dioxazine violet

◀ **1** *Mask some of the foreground corn stubble. Paint the sky in a watery Prussian blue. While working from the bottom upward, lay a wash of new gamboge, and let the colors merge. While the first washes are still damp, drop in a mix of new gamboge, raw sienna, and a little burnt sienna onto the foreground stubble. Use a clean tissue to lift out small highlight areas on the top right of the three nearest corn bales.*

▶ **2** *Paint the corn bales in a midtoned mix of new gamboge and raw sienna, dropping in burnt sienna for the darker areas. Use the same mix to define the foreground stubble with short, calligraphic strokes, following the ruts and making the marks less textured as they recede. Lightly define the cornfields in the far distance with pale dioxazine violet.*

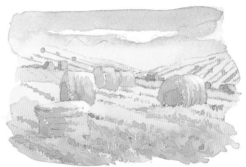

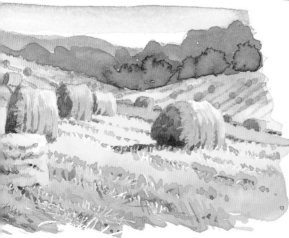

◀ **3** *Add dioxazine violet to the new gamboge and raw sienna mix, and paint the shadow sides of the corn bales. Paint the distant hill in dioxazine violet and the tree line in a mix of new gamboge, raw sienna, and Prussian blue. While this is still damp, drop in a more watery version of the same mix to suggest the tree shapes, and leave to dry. Remove the masking, and tint the stubble in places with new gamboge and burnt sienna.*

Colors

Field of sunflowers

new gamboge green gold burnt umber Prussian blue burnt sienna lemon yellow olive green dioxazine violet

◀ **1** *Lightly sketch the scene, making the foreground flowers larger than those in the background. Lay a wash of new gamboge mixed with green gold from the top of the paper down to the horizon, and a wash of new gamboge alone from the horizon to the lower edge of the paper.*

▶ **2** *While the washes are damp, drop in small dots of midtoned burnt umber for the flower centers above the horizon. Below the horizon, paint the negative spaces behind the flower heads in midtoned Prussian blue, drop midtoned burnt sienna into the flower centers; reinforce the small background flowers with circular strokes of lemon yellow. Leave to dry.*

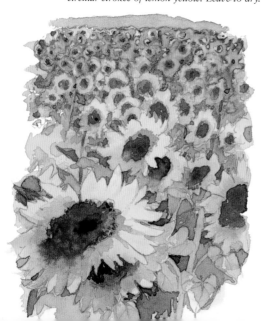

◀ **3** *While using a mix of Prussian blue and new gamboge, carefully paint the green leaves around the flowers, adding darker accents in olive green. Complete the flower centers in stronger colors of burnt umber, softening some edges with a clean damp brush, and dot in dark dioxazine violet for the very darkest areas of the flower centers.*

Colors

Prussian blue *raw sienna* *cadmium red*

Field of growing corn

◀ **1** *Mask out the foreground ears of corn and some small horizontal bands toward the horizon. Brush in pale Prussian blue for the sky. Then, while working from the bottom of the paper upward, lay a wash of raw sienna up to the horizon line. While these washes are damp, drop in stronger raw sienna (right) and Prussian blue (left) on the lower half of the paper and into the small bands on the horizon. Leave to dry.*

▶ **2** *Using a midtoned mix of Prussian blue and raw sienna, paint the small trees along the horizon. Using strong raw sienna, brush in the middle ground and foreground ears of corn, making sure your brush strokes follow the direction in which the corn is growing. Paint the negative spaces between the blades of corn in the left-hand foreground in Prussian blue and leave to dry. Rub off the masking fluid.*

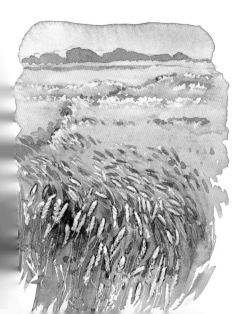

◀ **3** *Tint the unmasked corn ears and stems with a very pale mix of raw sienna, leaving some white. Using a very fine, pointed brush, define details on some of the corn ears in the immediate foreground in raw sienna and outline them in Prussian blue so that they stand out more clearly. Lastly, add a few small poppy heads, bottom left, in tones of cadmium red.*

Undergrowth

Spring thicket

Colors

green gold
phthalo blue
sap green
burnt sienna
olive green
burnt umber
cobalt blue
permanent rose

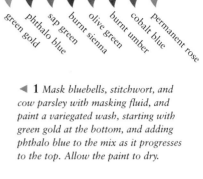

◀ **1** *Mask bluebells, stitchwort, and cow parsley with masking fluid, and paint a variegated wash, starting with green gold at the bottom, and adding phthalo blue to the mix as it progresses to the top. Allow the paint to dry.*

▶ **2** *This stage involves negative painting as some of the first wash must be retained. Carefully paint around some of the leaf and stalk shapes with a mix of sap green and phthalo blue, adding touches of burnt sienna at the top to suggest branches and twigs. Allow to dry, then rub off the masking.*

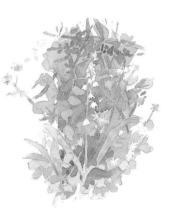

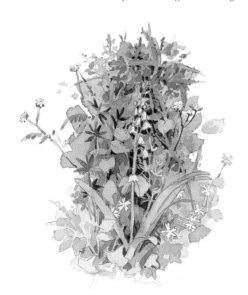

◀ **3** *Paint smaller shapes, both negative and positive, of grasses and leaves with sap green and phthalo blue, and drop in dark olive green for emphasis. Strengthen the branches with strong burnt umber. Finally, paint the bluebells with a mix of cobalt blue and permanent rose.*

Colors

green gold
sap green
cobalt blue
phthalo blue
olive green
dioxazine violet
brown madder
burnt umber

Summer thicket

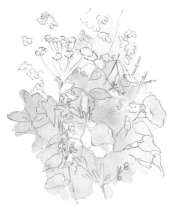

◄ **1** *Mask cow parsley, dog roses, and nettle flowers with masking fluid and paint a variegated wash using green gold, sap green, and cobalt blue.*

▶ **2** *With the first wash still wet, add stronger cobalt blue, and strengthen the first wash behind the convolvulus flowers and leaves with darker phthalo blue and sap green. Allow the paint to dry, then rub off the masking.*

◄ **3** *Continue to emphasize the negative spaces with dark mixes of olive green, sap green, and dioxazine violet. Add touches of brown madder to the convolvulus stems and buds. Paint seed heads of cow parsley with a mix of brown madder and burnt umber. Tint dog roses with pale brown madder.*

Undergrowth

Colors

raw sienna alizarin crimson phthalo blue dioxazine violet

Fall thicket

◄ **1** *Use masking fluid to mask one or two of the thickest bramble stems and some of the grasses. Paint a wash of raw sienna at the top edge, and brush in some individual leaves in the same color. While the paint is still wet, drop in splashes of alizarin crimson and phthalo blue, allowing the colors to blend. Leave to dry.*

► **2** *This next stage involves a lot of negative painting. While using alizarin crimson, phthalo blue, and raw sienna, carefully paint the background around some of the lighter leaves. Glaze over some of the leaves with a midtoned dioxazine violet and alizarin crimson. Continue adding depth to the background, especially in the center, but go no darker than a midtone.*

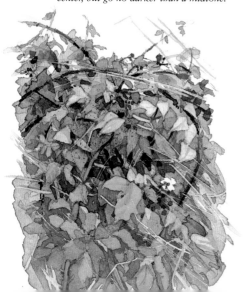

◄ **3** *While working from the center of the thicket outward, paint in small, dark negative shapes with alizarin crimson and dioxazine violet. Allow to dry, then rub off the masking fluid. Tint the grasses and bramble stalks with a mix of raw sienna and dioxazine violet, then do in some blackberries with the violet to finish.*

Colors

indigo burnt sienna sepia burnt umber alizarin crimson

Winter thicket

◀ **1** *Use masking fluid to mask the ferns and a few thin grasses. Paint the overcast gray sky in a pale wash of indigo and burnt sienna. Add sepia to the mix, and paint the lower undergrowth section. Leave to dry.*

▶ **2** *Build up the tones of the branches and twigs from light to dark, using a fine brush and a mix of indigo and burnt umber.*

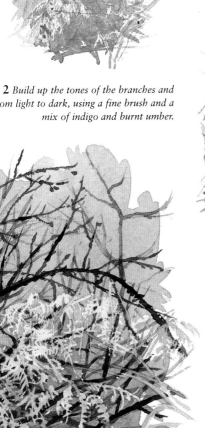

◀ **3** *Paint in the nearest and darkest branches and twigs with a mix of indigo and sepia, adding a few dots of alizarin crimson for the rose hips. Allow to dry, then rub off the masking fluid. Tint the exposed ferns and grasses with various shades of burnt sienna. Finally, paint some small, negative, dark shapes behind the fern fronds in sepia.*

Spring deciduous forests

Colors

phthalo blue
green gold
phthalo green
dioxazine violet
permanent rose
transparent yellow

◀ **1** *Use masking fluid to mask some of the light green foliage on the foreground trees. While starting at the top, lay a variegated wash of phthalo blue, changing to green gold down to the bluebell line, taking the color down into the tree trunks. Drop in phthalo green toward the right side. Leave to dry.*

▶ **2** *Paint the bluebells and the tree trunks in the bluebell area in a watery wash of dioxazine violet mixed with permanent rose. Paint the path in a mix of green gold and permanent rose, and paint the trees' shadows in dioxazine violet. When this is dry, stipple the shadow areas within the bluebells in a mix of dioxazine violet and phthalo blue. Stipple the background foliage in a mix of green gold and phthalo green. When all is dry, rub off the masking fluid.*

◀ **3** *Tint the exposed foliage shapes with pale transparent yellow. Paint the branches, twigs, and shadow details on the tree trunks in a mix of dioxazine violet and phthalo green. Lastly, stipple the darkest foreground foliage in a mix of green gold and phthalo green.*

Colors

Winter conifer forest in snow

phthalo blue
burnt sienna
dioxazine violet
French ultramarine
phthalo green

◀ **1** *Use masking fluid to mask some white snow shapes on the conifer foliage. Wet the paper above ground level and, while starting at the top, lay a variegated wash of pale phthalo blue, changing to pale burnt sienna. While it is still wet, drop in some dioxazine violet on the bottom half of the wash to blend. Leave to dry.*

▶ **2** *Paint the background tree trunks and a suggestion of the undergrowth in a mix of midtoned French ultramarine and dioxazine violet. Next, add the snow shadows on the conifer trees and on the ground, using washes of French ultramarine and phthalo blue. When this is dry, rub off the masking fluid, and soften the white shapes on the foliage with a clean, damp brush.*

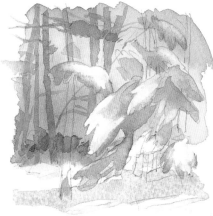

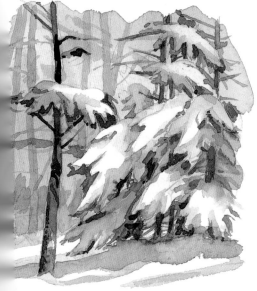

◀ **3** *The dark, final details pull the whole image together. Paint the foreground tree trunks, branches, and conifer foliage using two tones of phthalo green and burnt sienna mixes. Finally, strengthen the snow shadows on and under the main tree with phthalo blue.*

Trees

Colors

French ultramarine • transparent yellow • sap green • burnt umber • white gouache

Deciduous tree—spring

◀ **1** *Paint the sky with a graded wash of French ultramarine. Before it dries, lift out some clouds with a tissue or paper towel. Lay a wash of transparent yellow, sap green, and a small touch of burnt umber over the field. Leave to dry.*

▶ **2** *Paint the distant hills and foreground grass in a mix of French ultramarine and sap green. Add the trunk and the main branches of the tree in a mix of French ultramarine and burnt umber, varying the tones a little.*

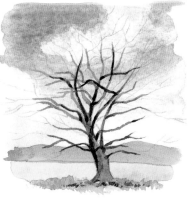

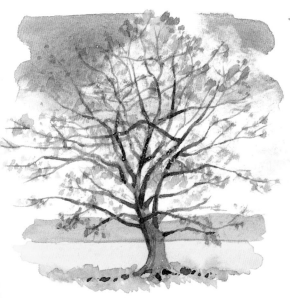

◀ **3** *While using a rigger brush and the same mix of French ultramarine and burnt umber, complete the smaller branches, taking the strokes right to the outside edge of the tree's outline. Finally, dab a sap green and transparent yellow mix gently over the tree for the leaves, taking care not to make the leaves too dense. Then spatter a mix of white gouache and transparent yellow over the center of the tree.*

Deciduous tree—summer

Colors

transparent yellow · sap green · raw sienna · cobalt blue · oxide of chromium · alizarin crimson · white gouache

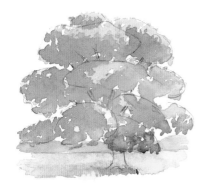

◄ **1** *Mix a pale, watery wash of transparent yellow, sap green, and raw sienna, and paint the main foliage masses, leaving small holes throughout. Paint the field in this color, too, and add cobalt blue to the mix for the distant hill. Add more sap green to the mix and paint the undersides of the foliage clumps and the left side of the tree, which is more in shadow, in this midtoned green before the first wash dries.*

▶ **2** *While the first washes are still damp, paint the darkest shadows in oxide of chromium. Use bold, simple strokes, mostly on the undersides of the clumps and on the left side of the tree. The colors should blend a little.*

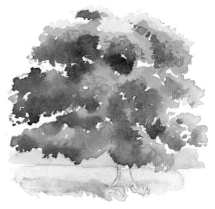

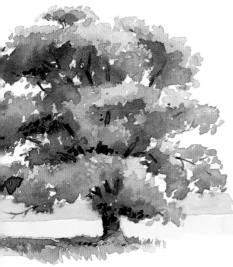

◄ **3** *Paint the trunk and those branches that can be seen in a mix of oxide of chromium and alizarin crimson, taking care not to paint branches across the lightest part of the foliage. Add some finer details on the twigs and a few spots of dark leaves in the shadows in dark oxide of chromium. Mix white gouache with a touch of sap green, and paint a few lighter-colored leaves to break up some of the dark areas. Paint the shadow under the tree with a dark green mix, as before.*

Deciduous tree—fall

Colors

raw sienna burnt sienna sap green dioxazine violet white gouache

◀ **1** *Paint a wash of raw sienna over the land, dropping in burnt sienna and sap green in the foreground. When this is dry, add the distant hills in a pale mix of burnt sienna and dioxazine violet. Stipple in the first layer of leaves with very watery raw sienna, making strokes across the tree and taking care not to make the leaves too dense.*

▶ **2** *While this is still damp, continue stippling on the leaves, using first burnt sienna and then touches of sap green and finally a darker mix of sap green and burnt sienna. The colors will merge in places. Leave to dry. Paint some fallen leaves under the tree in burnt sienna.*

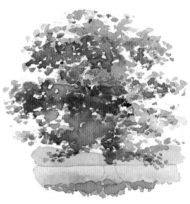

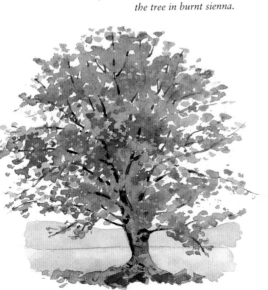

◀ **3** *Use a mix of dioxazine violet and sap green to paint the trunk and branches. Take the color behind the leaves where they come in front of the trunk and main branches. Lastly, by using white gouache tinted with burnt sienna, apply a few light dots of leaves, going over the dark branches and midtoned leaves.*

Colors

Deciduous tree—winter

raw sienna *burnt sienna* *indigo*

◀ **1** *Lay a variegated wash mix of raw sienna, burnt sienna, and indigo over the sky and land. When this is dry, paint the distant hills in pale indigo. Leave to dry.*

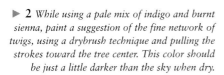

▶ **2** *While using a pale mix of indigo and burnt sienna, paint a suggestion of the fine network of twigs, using a drybrush technique and pulling the strokes toward the tree center. This color should be just a little darker than the sky when dry.*

◀ **3** *Paint the tree trunk and larger branches in varying tones of indigo and burnt sienna. Use a rigger brush to indicate some of the fine branches with feathery strokes, taking them to the outside edges of the tree— otherwise the earlier drybrush work could look like foliage.*

Willow trees

Colors

transparent yellow phthalo green alizarin crimson olive green burnt sienna

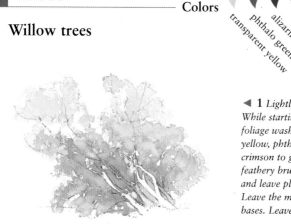

◄ **1** *Lightly sketch the outlines of the trees. While starting at the top, paint the first foliage washes, using mixes of transparent yellow, phthalo green, and a touch of alizarin crimson to gray the color a little. Use small, feathery brush strokes for the outside edges, and leave plenty of holes in the foliage masses. Leave the main tree trunks white toward the bases. Leave to dry.*

► **2** *Paint in the midtones of the gray greens using a stronger version of the transparent yellow, phthalo green, and alizarin crimson mix, stippling to suggest the very small leaf textures. Leave some of the first wash showing through, especially on the right-hand side where the foliage is in the light. Paint the grasses under the trees in transparent yellow and phthalo green.*

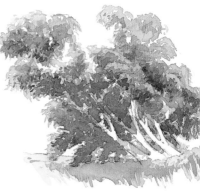

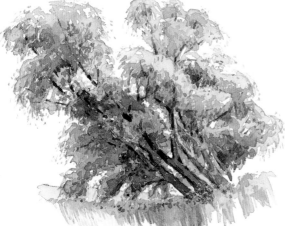

◄ **3** *Add darker gray greens in the foliage shadows, using a mix of phthalo green and olive green. Paint the tree trunks in a pale burnt sienna, then add shading to them using mixes of burnt sienna, phthalo green, and olive green. Paint the tree branches in the same colors.*

Colors

Prussian blue transparent yellow new gamboge olive green

ypress trees

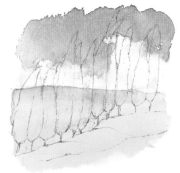

◀ **1** *Lay a Prussian blue wash for the sky, lifting out some clouds on the horizon with a tissue or paper towel. Lay a variegated wash from the horizon downward, starting with a mix of Prussian blue and transparent yellow and then changing to new gamboge in the foreground. Leave to dry.*

▶ **2** *By using a small filbert hog-hair brush and short upward strokes (to echo the direction in which the foliage grows), paint the group of trees in a mix of olive green and new gamboge. Feather the strokes at the top of the trees where the shape is more wispy.*

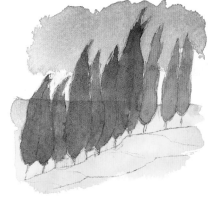

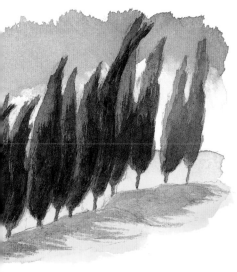

◀ **3** *While still using the hog-hair brush, stroke in a darker green mix of olive green and Prussian blue for shading, leaving some of the original wash on the left-hand sides of the trees. Lighten the tone toward the right of the image, as these trees are farther away. Use the same mix for the thin tree trunks, then glaze the shadows on the land in thin Prussian blue.*

Colors

quinacridone gold
burnt sienna
olive green
phthalo green
cobalt blue
white gouache
burnt umber

Silver birch trees

◀ **1** *With a small natural sponge, delicately stipple on some quinacridone gold foliage. When this is nearly dry, sponge on some burnt sienna.*

▶ **2** *While using a mix of olive green and phthalo green, sponge on some green foliage—mainly on the tree on the right, which will look the densest because it is in the foreground. Use a small brush and dot in leaves on the outer branches in the same color. Brush in long grass under the trees in a mix of phthalo green and cobalt blue. Add quinacridone gold in the foreground. Leave the tree trunks white.*

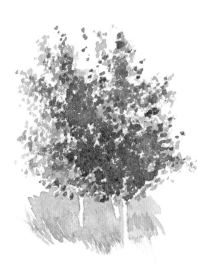

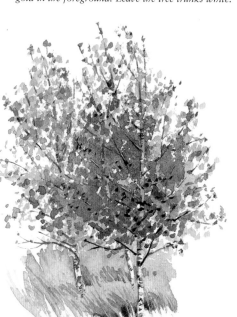

◀ **3** *Paint the light trunks in white gouache tinted with burnt sienna. Paint the dark brown, horizontal markings on the tree trunks in burnt umber. Add some wispy branches in burnt umber and a few dark leaves on the right-hand tree in dark olive green. Finally, stroke in grass shadows in two tones of olive green.*

Skies

Fair weather—sunset

quinacridone gold
French ultramarine
cadmium orange
alizarin crimson
light red

◀ **1** *Tilt the board slightly so that the paper is at an angle. Wet the area with clear water. While starting at the bottom edge and working upward, lay a graded wash of watery quinacridone gold, fading to a very pale shade in the center of the paper. Then, while working downward from the top, lay a graded wash of French ultramarine, allowing the two colors to blend where they meet. Place streaks of very pale French ultramarine at the center.*

▶ **2** *While this is still damp, stroke in cadmium orange, working upward from the bottom of the paper. Add a little alizarin crimson to the cadmium orange, and paint a few strips across the wet orange. Allow to blend a little.*

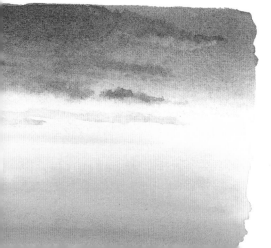

◀ **3** *While the paint is still damp, add a tiny amount of light red to a slightly darker tone of French ultramarine than you used in Step 1, making the mix less liquid. Paint horizontal bands of clouds at the top, making them thinner toward the horizon. Before this dries, add streaks of pale, dry cadmium orange on the undersides of the clouds that reflect the Sun.*

Colors

light red
raw sienna
French ultramarine

Layered clouds—midday

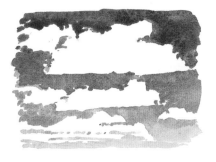

▶ **2** Note *how the undersides of the cumulus clouds have a soft edge, whereas the upper edges tend to be harder. While the blue wash is still wet, drop very watery, pale raw sienna onto the white cloud shapes, allowing it to touch the blue at the base of the clouds but not at the top. This gives a softer edge where the two colors meet.*

◀ **1** Note *how the clouds are rounded on the top and flatter underneath and how they become thinner toward the horizon. On dry paper and while working from the top, paint a graded wash of French ultramarine, taking the color around the edges of the cloud shapes.*

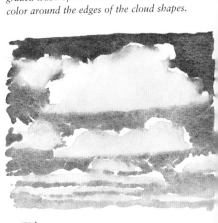

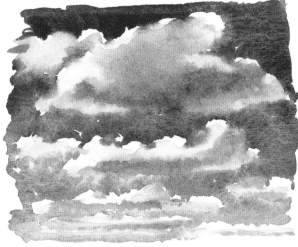

◀ **3** *Before the raw sienna has dried, make a darker, dryer mix of French ultramarine with a touch of light red, and drop it in onto the base of the clouds to create the shadows. The colors will blend a little.*

ummer clouds—early morning

cobalt blue
cadmium orange

◀ **1** *Wet the paper with a large, flat brush. Paint a thin strip of pale, watery cadmium orange at the bottom. Then, while working from the top downward, paint a graded wash of cobalt blue, allowing it to blend into the cadmium orange toward the bottom.*

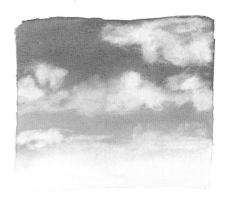

▶ **2** *Dip a round brush into clean water, and squeeze out the excess water with your fingers. Drag the brush across those areas of the paper where you want the clouds to be, rotating it as you go. This lifts off paint, creating the impression of soft, wispy clouds. Make the clouds narrower as you move toward the horizon.*

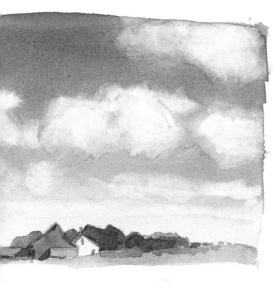

◀ **3** *There is no shadow on the clouds, just a faint hint of warm color. Before the wash is dry, stroke very pale cadmium orange onto the base of the clouds, using a barely damp brush.*

Skies

Colors

Approaching storm

◄ **1** *Tilt the board slightly, and soak the sky area of the paper with clean water. While starting at the top and working downward, lay a variegated wash in a mix of raw umber, indigo, and a touch of alizarin crimson, changing to just raw umber for the bottom half. Allow the colors to merge and leave to dry.*

▶ **2** *Tilt the board more steeply, to 45 degrees, and wet the sky area again with clean water. Using a flat brush and a midtoned indigo, start at the top edge and gently stroke in the color, allowing it to flow downward. Stop short of the horizon by turning the paper upside down so that the color flows back to the top edge of the sky. Collect any excess color on the top edge and turn the paper the correct way up, tipping the board at a gentle angle.*

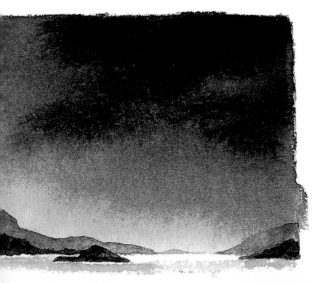

◄ **3** *While the paint is still wet, drop a strong, dark mix of indigo and a little alizarin crimson onto the top of the paper. Direct the flow of paint downward. When it has gone far enough, tip the paper in the opposite direction and leave it in this position to dry so that eventually the darkest part of the sky is on the top edge.*

Dramatic sky

French ultramarine
burnt sienna
phthalo blue
burnt umber

◄ **1** *Wet the sky area and wait a little for the water to soak in. If you start painting too soon, the paint will flow freely over the surface. For bold, splashy brushwork that will still blur, start painting before the paper loses its shine. Mix two colors: French ultramarine with a little burnt sienna, and phthalo blue toned down with a little burnt umber. Paint sweeping strokes in each color, using a large, flat brush.*

► **2** *Add more burnt sienna to the French ultramarine mix. Follow the marks made in Step 1, and add one or two horizontal lines on the horizon. This immediately adds some warmth to the sky: the aim here is to have both warm and cool grays.*

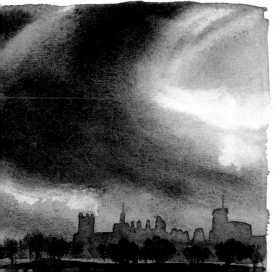

◄ **3** *Paint in the dramatic darks with a drier, stronger mix of ultramarine and burnt umber before the previous colors have dried. Dip a clean brush into water, squeeze out the excess water with your fingers, and lift out some white shapes. These shapes will soften a little as the paper dries. Do not be tempted to correct them—just wait and see what happens!*

Grassy knolls

Colors

transparent yellow
cobalt blue
new gamboge
quinacridone gold
oxide of chromium
olive green

◀ **1** *By working downward from the horizon, lay a wash of transparent yellow mixed with cobalt blue over the distant field. Change to pale new gamboge for the middle ground, and add quinacridone gold for the foreground. Lay a strip of pale cobalt blue for the sky. Leave to dry.*

▶ **2** *Now paint the greens. Start with a pale mix of cobalt blue and transparent yellow for the distant hill, and add more transparent yellow to the mix for the middle. Paint the trees along the edge of the large foreground field in a mix of new gamboge and cobalt blue. Paint the textured foreground grasses in a mix of new gamboge and oxide of chromium.*

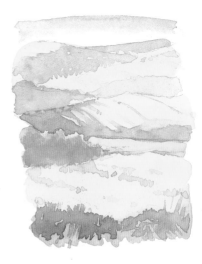

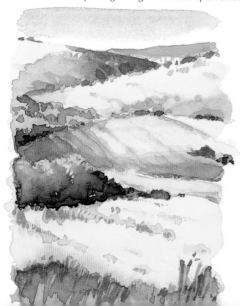

◀ **3** *Strengthen the distant hill with darker cobalt blue, and accent the middle ground with a mix of cobalt blue and oxide of chromium. Paint the foreground trees wet on wet with dark olive green, and use the same color to accent the nearest grasses.*

Rocky mountain

Colors

Prussian blue
French ultramarine
burnt sienna
burnt umber
sepia

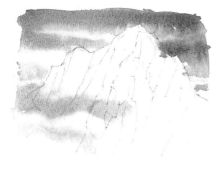

◀ **1** *Mask light edges at the top of the mountain. Brush the sky and mist-shrouded area at the center left with clean water. Brush horizontal strips of Prussian blue onto the damp areas. Reinforce the top bands of color with stronger French ultramarine mixed with a touch of burnt sienna. Leave to dry.*

▶ **2** *Rewet the misty area on the mountain with clean water to soften the edges of the blue. By using a drybrush and burnt sienna, paint vertical striations on those parts of the mountain that are facing the light, and paint the shadows in a mix of Prussian blue and burnt umber. Make sure that all your brush strokes follow the form of the mountain. Leave to dry completely, then remove the masking.*

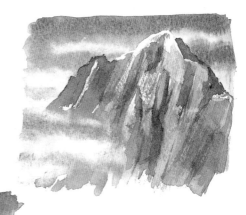

◀ **3** *Darken the rock face using varying tones of sepia mixed with Prussian blue and French ultramarine. Use a script liner brush for the finest lines. When everything is dry, scratch out further misty highlights with a craft knife.*

Tree-covered hills

cobalt blue · dioxazine violet · raw sienna · indigo · oxide of chromium · burnt sienna

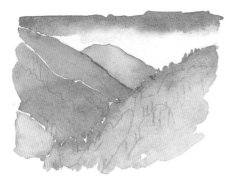

◀ **1** *Paint a strip of sky in cobalt blue, softening the edge with a damp, clean brush. For the most distant hill, lay a pale watery wash of dioxazine violet, dropping in pale raw sienna on the sunny left side. Paint the hills in front of it in mixes of indigo, oxide of chromium, and raw sienna, making the mixes bluer in the distance. Paint the large hill on the right in raw sienna with a little oxide of chromium. Leave to dry.*

▶ **2** *While using a round, pointed brush and short, vertical strokes, paint the trees on the most distant hill on the left with a mix of indigo and oxide of chromium. Proceed down the hill in layers, making the color bluer and paler on the right of the hill by dropping in watery cobalt blue. Allow to dry. Paint the nearer hills on the left in the same way, using a mix of oxide of chromium and burnt sienna. When dry, use a darker version of the same mix to restate the dark tree texture.*

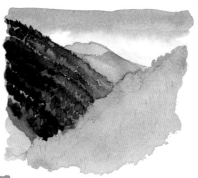

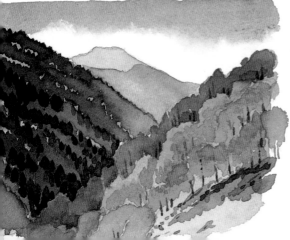

◀ **3** *The fall colors of the trees on the right hill catch the light. Paint the trees with mixes of raw sienna and oxide of chromium. The nearest trees are the brightest colored and also the most complete; the darkest and dullest-colored trees are farthest away, with only their tops visible. Lastly, add the thin tree trunks and ground texture, using a dark mix of oxide of chromium and burnt sienna.*

Mountains in snow

Colors

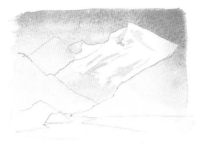

◀ **1** *Wet the paper with clean water, leaving only the distant right mountain dry, apart from its lower slopes. Lay a very pale raw sienna wash. While it is still damp, paint strips of French ultramarine mixed with a touch of light red into the sky, especially behind the far right mountain. Then, using a drier mix of the same color, stroke marks on this mountain following the direction of the slopes. Leave to dry.*

▶ **2** *With a midtone mix of French ultramarine and light red, and using very dry strokes, suggest the rocky structure of the distant snow-covered mountains. When this is dry, paint the mountain on the left in a darker, warmer version of the same mix, lightening the tone with water as you move down to the shoreline. Next paint the darkest mountain on the right in a mix of phthalo blue and light red, again lightening the tone toward the shoreline, and paint the foreground water with the same tone. Leave to dry.*

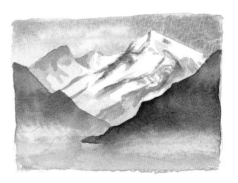

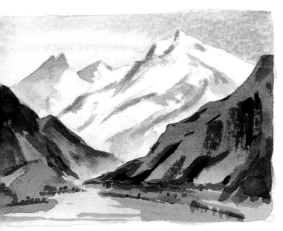

◀ **3** *Add the dark, textural details, using the French ultramarine and light red mix on the left mountain and dark phthalo blue and light red on the right mountain. Keep the paint fairly dry for these marks so that the direction of the brushwork can be seen: this helps to provide modeling. Finally, paint small dots and lines to describe the foreground.*

Mountains

Hazy hills in summer

Colors

cadmium orange
cobalt blue
olive green
burnt umber

◀ **1** *Lay a very dilute wash of cadmium orange over the paper, making it slightly darker toward the lower edge. Leave to dry.*

▶ **2** *Glaze cobalt blue over all the land area. Leave to dry. Paint the second hill from the top in the same tone of cobalt blue and leave to dry. While using slightly darker cobalt blue, paint the tree-covered hill in the middle ground, using the tip of a round brush to suggest the slightly jagged tree line. Add olive green to the cobalt blue mix and continue down to the next ridge. Leave to dry.*

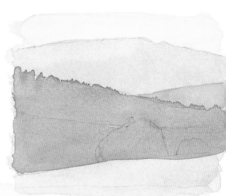

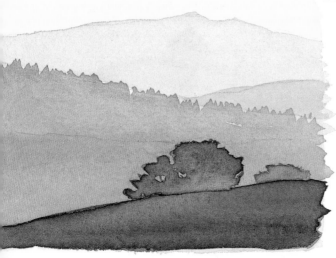

◀ **3** *Paint the foreground hill in a mix of cobalt blue, olive green, and burnt umber. Leave to dry. While using the same mix, add the trees that are just over the brow of this hill, dropping in watery cobalt blue at the point where the trees meet the top of the ridge.*

Colors

Rocky plains

◀ **1** *Paint horizontal lines of watery phthalo blue in the sky. Next, paint the palest tints on the land, starting at the horizon with a mix of raw sienna and translucent orange and then changing to translucent orange alone halfway down. Lay a wash of raw sienna over the foreground rocks, and blot out a few light patches with a tissue or paper towel. Leave to dry.*

▶ **2** *Paint the background hills, using cadmium orange on the peak and phthalo blue on the rest of the shapes. Mix raw sienna and cadmium orange, and paint the midtoned areas on the plains. Paint the darkest areas of the foreground rocks with translucent orange mixed with a touch of burnt sienna.*

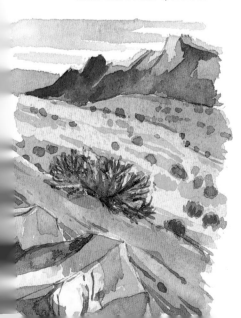

◀ **3** *Use phthalo blue to add darker accents to the mountain and dot in small clumps of brushwood, making them larger and darker toward the foreground. Note the spiky detail on the largest clump. Add cool shadows to the foreground rocks, again with tones of phthalo blue, and paint lines of burnt sienna just behind the rocks.*

Inland water

Reflections of mountains

Colors

cadmium orange
phthalo blue
dioxazine violet
permanent rose

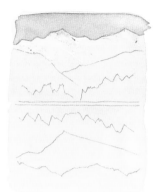

◀ **1** *Mask the snow-covered mountain tops. Then lay a wash of pale cadmium orange over the whole paper, and leave to dry. Wash a pale mix of phthalo blue and dioxazine violet over the sky, and leave to dry.*

▶ **2** *Paint the snow-covered mountain in a pale mix of dioxazine violet, permanent rose, and a little cadmium orange. Leave to dry. Paint the nearer mountains in midtoned versions of the same mix, lightening the tone toward the water. Leave to dry. Mix phthalo blue and dioxazine violet with a little cadmium orange, and paint the trees along the shoreline. When the trees are almost dry, scratch out the shapes of tree trunks with a palette or craft knife. When completely dry, remove the masking.*

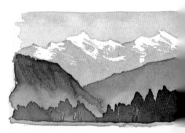

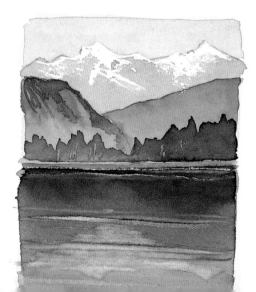

◀ **3** *Cover the water area with a pale wash of the sky color. While this is still damp, paint the mountain reflections in a mix of dark phthalo blue and cadmium orange. Stroke a clean, damp script liner brush across the water before it is completely dry to create gentle ripples, and use a palette knife to scratch out a couple of horizontal lines. Leave to dry, then use a craft knife to scratch out a thin line along the shore.*

Reflections of trees

Colors

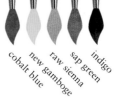

cobalt blue new gamboge raw sienna sap green indigo

◄ **1** *Stroke a candle across the water on the far side of the lake. Lay a graded wash of cobalt blue over the sky as far down as the horizon, and then a mix of new gamboge and raw sienna down to the water. With cobalt blue, suggest ripples on the water using broken, expressive brush strokes. Leave to dry.*

► **2** *Paint the distant trees in a mix of cobalt blue and sap green. Paint the foliage clumps at the water's edge with the same mix plus new gamboge. While the paint is still damp, stipple sap green on the foreground trees and scratch out the tree trunks with a palette knife. Leave to dry.*

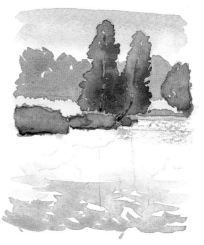

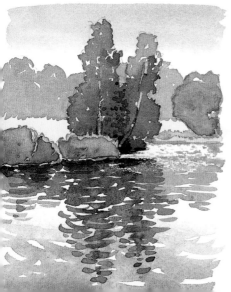

◄ **3** *By using a mix of indigo and sap green, paint the reflections in the water. Use short, curved brush strokes, making them larger and farther apart in the foreground. Add a little more indigo to the mix, and paint the dark areas on the bank side.*

Inland water

sepia
raw sienna
French ultramarine
Prussian blue

Rowing boat on a lake

◀ **1** *Wash a pale, watery mix of Prussian blue and French ultramarine over the sky down to the horizon line. While using a clean, damp brush, lift out a strip of color above the hill and then wash in pale raw sienna. Lay a wash of pale raw sienna over the water, leaving a small white shape on the boat where it catches the light. Leave to dry.*

▶ **2** *Paint the distant hill in a midtoned mix of Prussian blue and French ultramarine, fading the color out on the right. While working upward and painting around the highlights on the boat and rocks, lay a graded glaze of the same mix over the water, making it very pale at the horizon. Leave to dry, then paint the tree clump in a mix of Prussian blue and sepia.*

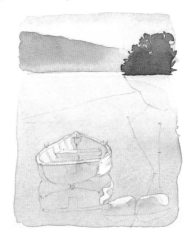

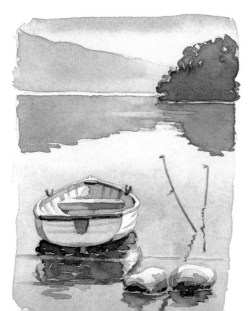

◀ **3** *Paint the reflections of the hill and trees, making the reflection of the hill darker and the reflection of the trees lighter than the actual objects. Build up the tones on the boat and rocks with sepia and Prussian blue. Leave to dry. Then paint the reflections of the boat and rocks, using slightly wavy, broken brush strokes. When dry, lift out one light water ripple with a clean, damp brush.*

Colors

Prussian blue raw umber burnt umber sepia

Shallow water

◄ **1** *Dot masking fluid over the light, sparkling water. Wash a mix of Prussian blue and raw umber over the water. While the paint is still wet, drop in underwater rock shapes in a mix of raw umber and burnt umber, allowing the colors to blend a little. Wash pale raw umber over the bankside rocks, blotting out highlights with a tissue or piece of paper towel.*

► **2** *Work quickly, before the first washes have dried, and paint wavy lines around the underwater stones using a small brush and dark sepia paint. Dip a clean script liner brush into water and sketch long wavy lines over the top of the previous shapes to remove a little color. Leave to dry.*

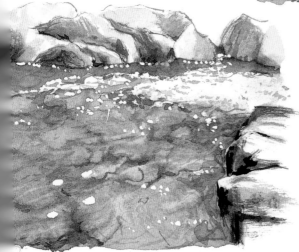

◄ **3** *While using a dry brush and burnt umber, paint the dark tones on the distant rocks. Repeat on the foreground rocks, adding dark accents of sepia and using a script liner brush for firmer, paler marks. Allow to dry, then rub off the masking fluid and soften the white water shape in places with lines of pale Prussian blue mixed with burnt umber.*

Inland water

Creating movement

Colors

Prussian blue
indigo
transparent yellow
raw sienna
olive green

◀ **1** *Mask out a few light, horizontal ripples on the water. Lay a wash of a pale mix of Prussian blue and indigo over the water, darkening the tone at the lower edge. Then lay a loose wash of transparent yellow over the distant trees and riverbank, omitting the most distant trees.*

▶ **2** *Paint the distant trees on either side of the riverbank, using Prussian blue in the background and warmer greens as you move toward the foreground. These greens are made from various mixes of raw sienna, Prussian blue, and olive green. When dry, add darker tones using the same colors.*

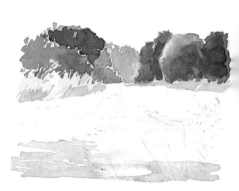

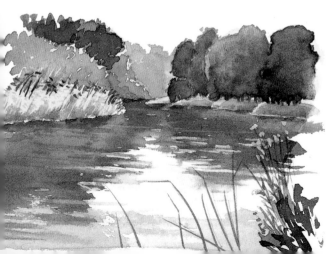

◀ **3** *Wet the river with clean water, and wait a little for the water to soak into the paper. Then, using darker tones of the tree colors, paint the trees' reflections. Use horizontal strokes, spacing them more widely at the lower edge. Leave to dry. Rub off the masking fluid and soften where necessary. Add foreground grasses and flowers in indigo and raw sienna.*

Grassy riverbank with plants

Colors

green gold
French ultramarine
burnt sienna
dioxazine violet
indigo

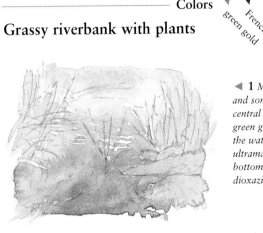

◀ **1** Mask ripples in the top half of the water and some grass on the bank edges. Paint the central iris and grassy banks with a wash of green gold, taking the color into the water. Paint the water in a graded wash of French ultramarine, making it slightly darker toward the bottom. Add a mix of burnt sienna and dioxazine violet at the bottom edge.

▶ **2** While the water is still damp, brush on curving strokes of dark French ultramarine and then ripples with a small brush and clean water. Leave to dry. Loosely paint the darker iris leaves on the bank in a strong mix of green gold and indigo. Leave to dry.

◀ **3** Remove the masking. Add darker accents to the iris leaves with a stronger green gold and indigo mix. Tint the white leaf shapes and short grasses in green gold. Paint the wavy lines of the reflections in mixes of French ultramarine, green gold, and dioxazine violet. Paint the muddy bank with a mix of burnt sienna and dioxazine violet.

Stream with rocks and pebbles

indigo Prussian blue dioxazine violet raw sienna burnt sienna

◀ **1** *Wash pale indigo over the rocks, and leave to dry. Paint a graded wash of a mix of Prussian blue, dioxazine violet, and raw sienna over the water. At this stage, the water will be very similar in tone to the rocks.*

▶ **2** *Build up tone in the water by adding directional brush marks of the same mix, making the mix slightly darker and spacing the lines farther apart toward the lower edge. Paint the midtones on the rocks, using varied mixes of Prussian blue, raw sienna, and a touch of dioxazine violet, allowing some of the first wash to show through.*

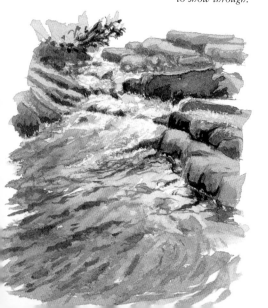

◀ **3** *Add dark accents to the foreground rocks in a mix of indigo and burnt sienna. Paint the top left foliage with broken strokes of indigo. By using a script liner brush and a mix of Prussian blue, dioxazine violet, and indigo, paint thin lines in the water, curving downstream. When this is dry, use a craft knife to scratch out highlights on the water.*

Waterfall

Colors

burnt sienna
French ultramarine
transparent yellow

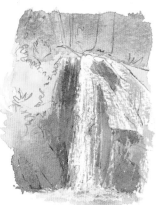

◀ **1** *Mask the water at the base of the waterfall. Paint the sides of the waterfall in burnt sienna, adding French ultramarine for the shadow areas. Wash transparent yellow over the foreground foliage and a mix of transparent yellow and French ultramarine over the area above the waterfall. Leave to dry.*

▶ **2** *Paint around the foliage shapes on the left in a darker mix of French ultramarine and transparent yellow. Paint the background above the waterfall in a midtoned mix of French ultramarine with a touch of burnt sienna. Leave to dry.*

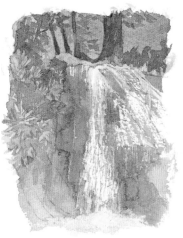

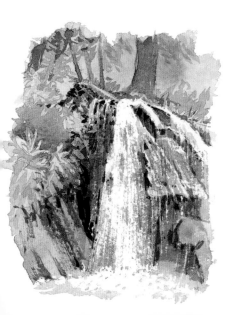

◀ **3** *Paint dark shadows on the rocks in a mix of French ultramarine and burnt sienna, varying the color from cool to warm. Brush pale grays into the waterfall itself. Leave to dry. Remove the masking, and scratch out a few vertical water lines with a craft knife. Add final accents to the rock in a dark mix of French ultramarine and burnt sienna.*

Walls and fences

Colors

raw sienna burnt umber French ultramarine cadmium red

Stone wall

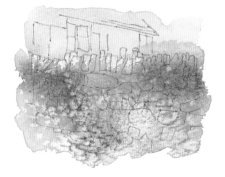

◀ **1** *Drag candle wax over some of the top stones in the wall, then paint a wash of raw sienna over the whole paper, adding a stronger raw sienna to the wall area. Drop burnt umber and French ultramarine onto the wall in places, and then sprinkle some salt randomly over the wall. Leave to dry.*

▶ **2** *Rub off the salt, spray the wall with clean water, and brush on a darker mix of raw sienna and burnt umber. While this is still wet, brush a cooler mix of French ultramarine and cadmium red onto the stones on the right. Continue down the wall, roughly painting around the stones. Paint the barn roof in pale French ultramarine and the doors in pale burnt umber.*

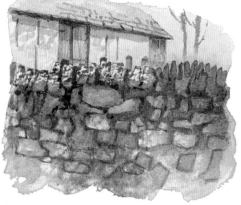

◀ **3** *While the wall is still damp, paint thin lines around the stones in darker mixes of the previous colors. Paint a shadow under the eaves in a mix of French ultramarine and cadmium red. Finally, paint the details on the barn and the background trees in a mix of French ultramarine and burnt umber.*

Colors

quinacridone gold, cobalt blue, olive green, dioxazine violet

Picket fence

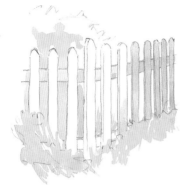

◀ **1** Paint the base of the fence and the rear of the right-hand side pickets with a wash of quinacridone gold, feathering the paint to suggest grasses. Add a touch of cobalt blue to the fence paint as the latter recedes.

▶ **2** Use a pale olive green to paint in distant foliage behind the central pickets and add more details to the grasses at the bottom right. Use a light wash of dioxazine violet to cast some shadows on the fence.

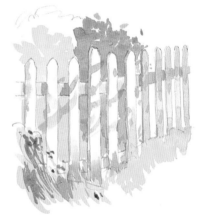

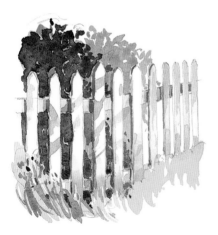

◀ **3** Deepen the foliage behind the nearest part of the fence with a darker olive green. Build up small shadow details to the pickets, to finish with darker dioxazine violet.

Walls and fences

Colors

Rusty metal gate

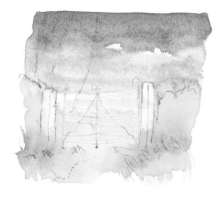

◀ **1** *Mask the gate. Lay a graded wash of cobalt blue over the sky, leaving small white clouds. Lay a wash of pale new gamboge from the horizon down to the bottom of the paper. While this is still wet, drop in burnt sienna at the base of the walls and lift color from the gate posts with a clean, dry tissue. Leave to dry.*

▶ **2** *Brush a mix of phthalo green and burnt sienna onto the walls, leaving some of the first wash showing through. Paint the trees on the horizon in cobalt blue. Slightly dampen the sky, and paint the tree trunks behind the gate in a mix of phthalo green and dioxazine violet. Paint a touch of burnt sienna behind the gate post. Leave to dry, then remove the masking.*

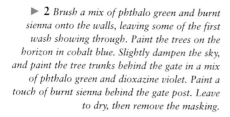

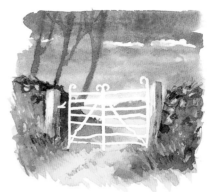

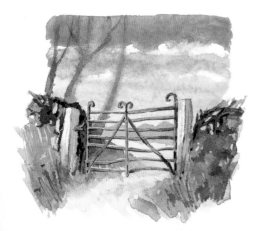

◀ **3** *Paint the rusty gate in pale burnt sienna, dropping in dioxazine violet. Add darker burnt sienna and touches of phthalo green for detail. Leave to dry.*

Colors

green gold
burnt sienna
cobalt blue
olive green
burnt umber
indigo

Wooden gate

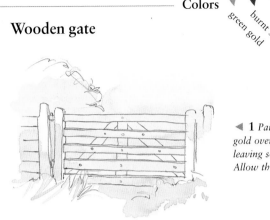

◀ **1** *Paint a fluid pale wash of green gold over the gate and background, leaving some parts of the gateposts white. Allow the paint to dry.*

▶ **2** *Paint the gate with a mixture of burnt sienna and cobalt blue, varying the mix here and there. Add foliage behind and in front of the gate with a mix of olive green and cobalt blue.*

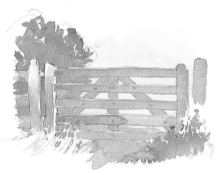

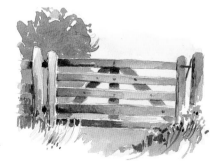

◀ **3** *Add further washes to the gate using the same mix as before. Show shadow areas with a stronger, cooler mix, varying the tones. Dark burnt umber and small touches of indigo can be used for final small details.*

Covered bridge

Colors

Prussian blue
quinacridone gold
brown madder
burnt umber

◀ **1** *Paint a strip of sky in pale Prussian blue. Paint the foreground foliage in pale quinacridone gold, and leave to dry. Loosely wash pale brown madder over the wooden bridge, leaving some white highlight areas. Wet the foreground water and drop in Prussian blue at the lower edge, with a hint of brown madder toward the bridge. Leave to dry.*

▶ **2** *Paint the distant hill in pale Prussian blue and the hill on the left in a mix of Prussian blue and quinacridone gold. Glaze patches of pale Prussian blue on the bridge roof and walls for shadows. When dry, add a darker shadow under the roof and on the buttress with a mix of Prussian blue and brown madder. Paint the tree on the right in a mix of Prussian blue and burnt umber.*

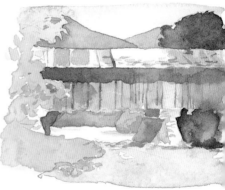

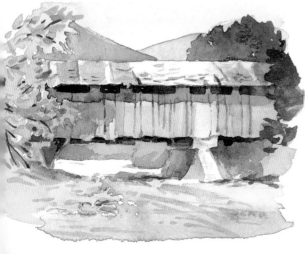

◀ **3** *Paint the windows and joists of the bridge in a mix of Prussian blue and burnt umber. Add details to the tree on the left and to the bank in quinacridone gold and burnt umber. Darken the tree on the right with the same mix plus Prussian blue. Paint ripples on the water in a very pale mix of Prussian blue and brown madder.*

Stone bridge

Colors

quinacridone gold · cobalt blue · cadmium orange · burnt sienna · dioxazine violet · burnt umber

◀ **1** *Mask a thin strip along the top of the bridge and a few ripples in the water. Wet the paper from the top down to the water's edge, and lay a wash of quinacridone gold. While using a clean tissue, lift off color from the distant trees. While the first wash is still damp, wet the paper from the bridge downward and allow the color to drift into this area. Darken the bridge shadows with stronger quinacridone gold. Leave to dry.*

▶ **2** *Glaze the trees in the far background in pale cobalt blue. Paint the foliage masses behind the bridge in pale cadmium orange, dropping in burnt sienna and watery dioxazine violet in places. Paint the shaded sides of the bridge in dioxazine violet, adding details in burnt sienna or cobalt blue. Leave to dry, then remove the masking above the waterline.*

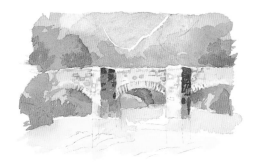

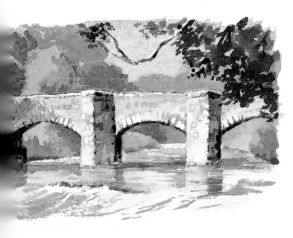

◀ **3** *Paint the trees on the left with a mix of cobalt blue and burnt sienna. Paint the dark foliage on the right foreground tree with a midtoned mix of dioxazine violet and burnt sienna. Paint the stonework details on the bridge in dioxazine violet. Paint the reflections of the bridge in a paler version of the previous colors. Wash pale cobalt blue across the surface of the water, and brush on mixes of the previous colors. Allow to dry, then remove the masking.*

Distant road

Colors

phthalo blue
burnt sienna
raw sienna
translucent orange
cadmium orange

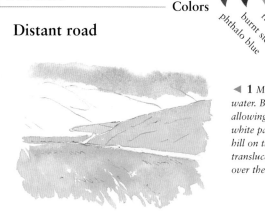

◀ **1** *Mask the road. Wet the sky with clean water. Brush in phthalo blue and burnt sienna, allowing the colors to merge. Leave some white paper above the mountains. Paint the hill on the right in a mix of raw sienna and translucent orange, and wash cadmium orange over the foreground. Leave to dry.*

▶ **2** *Paint a patch of pale raw sienna on the top of the left-hand mountain, and let it dry. Wash a phthalo blue and raw sienna mix over the distant mountain, and paint the left-hand mountain in mid-toned phthalo blue. Add texture to the hill on the right with a mix of raw sienna and cadmium orange. Wash a slightly darker mix of burnt sienna and raw sienna over the foreground, and paint vertical strokes of burnt sienna for the grasses. Loosely paint the foreground rocks in translucent orange. Leave to dry.*

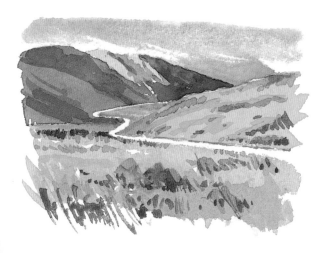

◀ **3** *Paint shadows on the left-hand mountain in dark phthalo blue, making the tone darker toward the right. Leave to dry, and then remove the masking. Paint a few dark accents in the foreground in phthalo blue and burnt sienna. By using a craft knife, loosely scratch out some diagonal lines in the sky to indicate movement.*

Bridle path

Colors

green gold · sap green · burnt sienna · indigo · dioxazine violet

◀ **1** *Lay a variegated wash on the grassy shoulders, changing from green gold in the background to sap green in the foreground. Suggest the stony texture of the track with dotted strokes of a burnt sienna and green gold mix, and then paint the grass along the center of the track in sap green.*

▶ **2** *Paint the distant trees in green gold and sap green, adding a darker mix of sap green and indigo while still damp. Paint the grass on the left-hand shoulder in the same sap green and indigo mix, leaving some of the first wash showing through. Paint the right-hand shoulder, using a mix of sap green and green gold in the far distance and sap green in the foreground.*

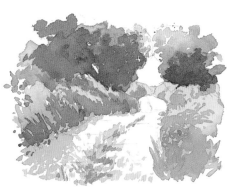

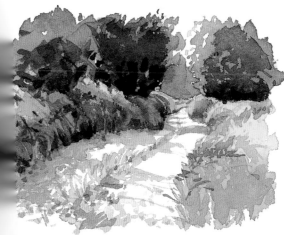

◀ **3** *Paint the area between the trees in the far distance in a mix of dioxazine violet and sap green. Paint the darkest greens on the trees in a mix of indigo and sap green. Leave to dry. Paint shadows across the path in pale dioxazine violet.*

Red barn

Colors

raw umber
French ultramarine
brown madder

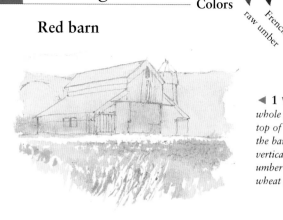

◀ **1** *Wash dilute raw umber over the whole paper, except for the distant hill, the top of the silo, and a strip at the base of the barn. While this is still damp, paint vertical strokes of a stronger mix of raw umber in the foreground to suggest a wheat field. Leave to dry.*

▶ **2** *Wet the distant hill with clean water, and paint it in a mix of French ultramarine and brown madder. Leave to dry. Paint the barn walls and silo in a mix of brown madder and French ultramarine, making the silo a little cooler in color. Add raw umber to the mix, and paint the tree on the left. Leave to dry.*

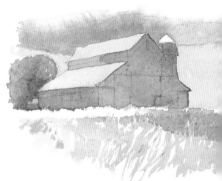

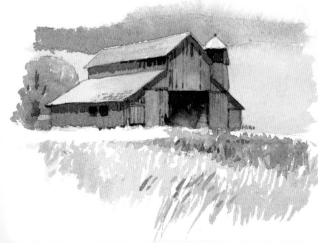

◀ **3** *Paint the shadows under the roofs and vertical lines on the barn walls in a mix of French ultramarine and brown madder. Paint the barn interior in brown madder, dropping in dark French ultramarine while the paint is still damp. Paint the roofs with a pale wash of French ultramarine. Lastly, paint the darkest tones on the silo and barn windows in a mix of French ultramarine and brown madder, and the foreground wheat ears in strong raw umber.*

Stone farmhouse

cobalt blue *raw sienna* *light red* *dioxazine violet*

◀ **1** *Mask the sunlit sides and edges of the building, the window edges, and the straw bales. Lay a graded wash of cobalt blue over the sky, and leave to dry. Wash pale raw sienna over the rest of the paper. While this is still damp, wash darker raw sienna over the foreground. Use a clean tissue to blot paint off the farmhouse to suggest texture.*

▶ **2** *Paint the roofs in dilute light red. Spatter light red randomly into the foreground and leave to dry. By using a mix of light red and cobalt blue, paint some of the tile ridges on the roofs, the windows and the doors. Darken the shaded side of the straw bales with raw sienna.*

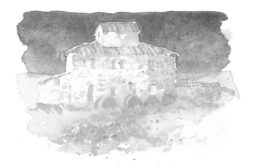

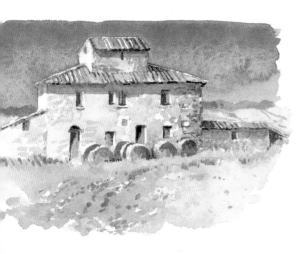

◀ **3** *Use midtoned dioxazine violet to paint the shadows under the eaves, some of the stone detail on the right of the house, and the dense shade on the straw bales. Brush a darker mix of light red onto the tiles. Add details to the doors, windows, and roofs in a mix of dioxazine violet and light red. Finally, paint the distant trees in cobalt blue.*

Tractor

Colors

raw umber burnt sienna brown madder French ultramarine

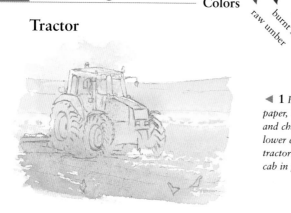

◀ **1** *Paint a pale variegated wash over the paper, beginning with raw umber at the top and changing to burnt sienna toward the lower edge. Paint the top and hood of the tractor in brown madder and the inside of the cab in pale French ultramarine. Leave to dry.*

▶ **2** *Glaze a thin mix of French ultramarine and brown madder over the top of the field. Paint the foreground to the left of the tractor in a mix of burnt sienna, brown madder, and French ultramarine. Paint the shaded areas of the tractor in a slightly bluer version of the mix. Brush a mix of French ultramarine and brown madder over the lower parts of the tractor and into the shadows on the ground, indicating the stony texture a little. Leave to dry.*

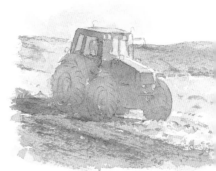

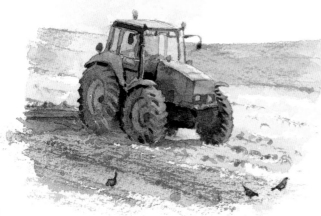

◀ **3** *Paint the tread on the tires and the shadows under the mudguards in a mix of French ultramarine and brown madder. Paint the smallest dark accents and the crows in a darker version of the same mix.*

Colors

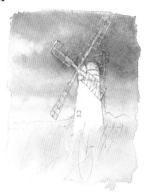

Windmill

raw sienna
French ultramarine
indigo
burnt umber
dioxazine violet

◀ **1** *Mask the sails, the top of the windmill, and some foreground grasses. Wet all the paper except the body of the windmill, and lay a wash of pale raw sienna. Start painting the sky with a mix of French ultramarine and indigo at the top. Change to a mix of burnt umber and dioxazine violet for the darker clouds, and allow the color to pale toward the horizon.*

▶ **2** *When the sky wash is almost dry, paint the trees along the horizon in the same mix of burnt umber and dioxazine violet. While using a script liner brush, paint the dark foreground grasses in strong raw sienna. Leave to dry. Paint the body of the windmill in burnt umber, dropping in indigo on the right-hand side while it is still wet. Leave to dry, then remove the masking.*

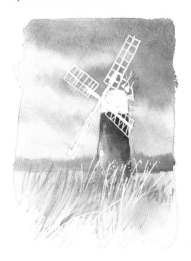

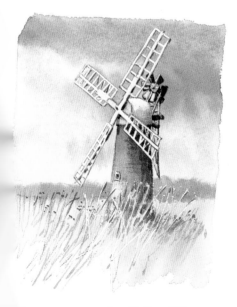

◀ **3** *Use a small brush and a mix of indigo and burnt umber to paint the dark details on the windmill. Sharpen the detail on the sails by outlining them with a soft pencil. Dot in the darker grasses on the left with burnt umber.*

CREDITS

ARTIST Adelene Fletcher
EDITOR Kate Tuckett
ART EDITOR AND DESIGNER Jill Mumford
ASSISTANT ART DIRECTOR Penny Cobb
COPY EDITOR Sarah Hoggett
PROOFREADER Pamela Ellis

ART DIRECTOR Moira Clinch
PUBLISHER Piers Spence

Manufactured by Universal Graphics (Pte) Ltd., Singapore
Printed by Leefung-Asco Printers Ltd., China

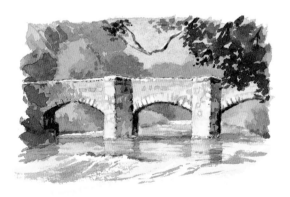